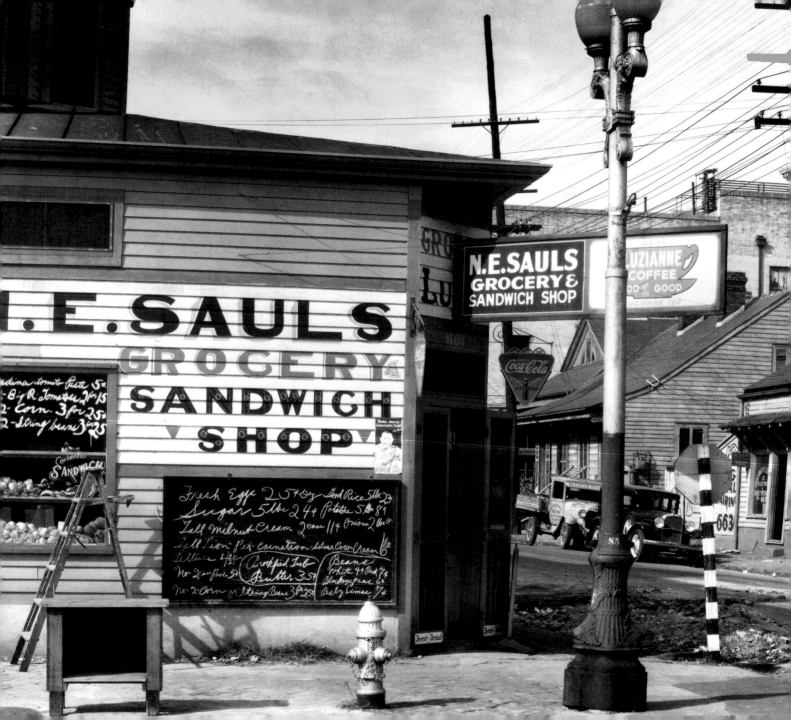

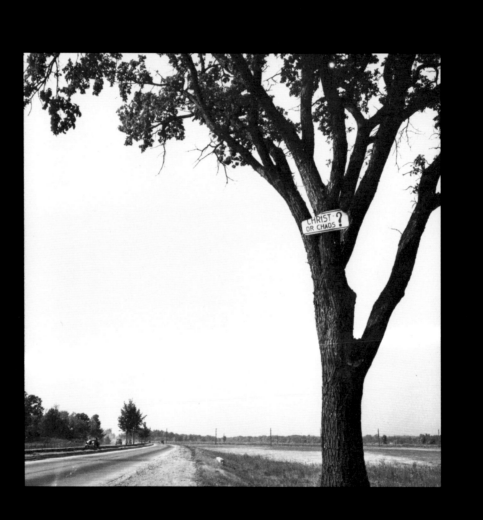

AND SHAVING

MONDAY & GREEN.

TRUCK EXCURSON
THURSDAY JULY 2 1936
TRUCK LEAVE LYSE CAFE
AT 4 OCLOCK GOING TO
OAK GROVE AND UNION TOWN
TO DINE AND DANCE
COME FOLLOW THE CROD
TO BROWNS COME AND
TRUCR WITH US ADM.
25¢

With an essay by
Andrei Codrescu

Walker Evans
SIGNS

The J. Paul Getty Museum, Los Angeles

Introduction

The photographer Walker Evans (1903–1975) was born in St. Louis and literally raised on advertising. His father, Walker Evans, Jr., began his career as an advertising agent for the Wabash Railroad and quickly rose to the position of copywriter for the Chicago firm of Lord and Thomas. At the top of his very young profession and following the newest trends, Evans's father next moved the family from Chicago to Toledo, Ohio, to pursue accounts in the automobile industry. This upbringing— along with his close friendship with the writer James Agee (himself an avid fan of motion pictures) and more than twenty years spent as photographer and editor at *Fortune* magazine— all contributed to Evans's astute observation of popular culture, particularly signage of any kind.

Although Evans is most often associated with the Depression-era South and the book *Let Us Now Praise Famous Men*, which he and Agee co-authored, he was a most urbane man who loved French literature, married a painter, and, after a stint in Greenwich Village, made his home on the Upper East Side of Manhattan. His photographic equipment varied over the years from an 8 × 10-inch view camera used to record rural churches in Alabama, to a concealed hand camera that captured anonymous portaits in the New York subway, to an SX-70 camera furnished by Polaroid and employed to portray his students at Yale University. But during a career covering nearly fifty years, Evans's photographic subjects

A Technical Note

Walker Evans: Signs contains fifty gelatin silver photographs selected from the Getty Museum's collection, the largest holding of prints made by Walker Evans himself. A few have been slightly cropped, and a very few have been significantly cropped. All the images are reproduced in their complete form with their dimensions and accession numbers in the back of this book. Additional information about these prints as well as the Museum's holdings of Evans's work can be found in *Walker Evans: The Getty Museum Collection* (1995).

were surprisingly constant: architecture, especially anything vernacular; portraiture, particularly the man-on-the-street; and signs—billboards, theater marquees, graffiti, street signs, advertising posters, hand-painted shop fronts. His preoccupation with signs extended beyond the graphic elements and significant texts they might provide. He admired signs as objects, he collected them (whether from street corners or antique shops), and, in the early 1970s—well before Postmodernism had arrived—he exhibited signs, sometimes next to his own photographic representations of them. At *Fortune* Evans designed layouts for mass consumption and, after that, taught photography and graphic design at Yale. It is hoped that the production of this book reflects his own keen interest in typography and in creative ways of combining the visual and the verbal, the abstract and the representational. An essay by Andrei Codrescu, the Romanian-born poet, novelist, and cultural commentator, joins Evans's images in interpreting the exemplary American subject of signs.

Judith Keller
Associate Curator
Department of Photographs

ix

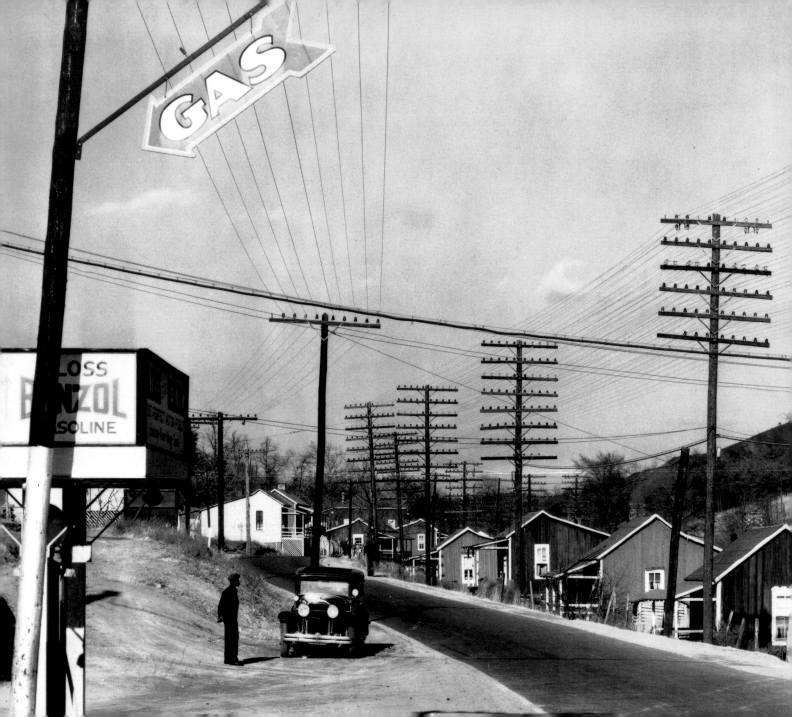

Andrei Codrescu

Modernism was in awe of the Word,

an awe matched only by its total mistrust of what words had come to mean in the bourgeois world: debased in advertisements, spoken without meaning on the streets, issuing fully stillborn from the mouths of politicians, sprayed like cream swirls on the rococo pastries of art. The twentieth century busted out in a babble of words whose din was overcome briefly only by the loud explosions of World War I, the trench war, the war of the explosive Mr. Nobel. Perched there on the rim of the black crater left by bombs, the dada poets and writers crowed their ironic songs. The dada poem was made out of cut-up newspapers; the dada picture was made out of cut-up advertisements; collage became the preeminent response to the faux-seriousness of commerce and its forced jollity. And it was up to photography to rescue whatever lyric lament was still there.

After the Great War, a black-and-white giddiness seized the world. With the crater at its back, Walker Evans's generation was launched on a high-minded quest that was simultaneously frivolous and cabalistic. James Joyce was the priest of this new religion of art that elevated the vulgate to a dizzying perfection.

Walker Evans was raised on these High Modernists, and his beginnings were steeped in literature. Born in 1903, he caught the full force of modernist Paris in 1926–27. He intended to be a writer, and his friendships were literary. He attended lectures at the Sorbonne and was no doubt conversant with the surrealist revolution. He took snapshots with a Kodak vest-pocket camera; he may even have worked briefly at Nadar's studio. This apprenticeship is significant in view of the common perception of Walker Evans as the documentarian of Depression-era America. He was that, but the stubborn pull of aesthetic modernism is ever-present in all his work. Active in the air of post-war Europe were the two faces of modernism: the highly colored, poetic, gravity-defying, and very French manipulation of reality in order to achieve a sur-reality; and the dead earnest, messianic fervor of Ezra Pound and various weighty fascist-communist futurisms. (On this side of things one must also count the constructivist revolution, with its technological fetishes.) While surrealism floundered in the thirties, the ominous, Poundian seriousness of the second strain prevailed. And the world, never very friendly to fiction, took itself very seriously indeed.

Back in New York in 1927, Evans lived in Brooklyn Heights and met Hart Crane. There is this in *The Bridge*, Crane's famous poem inspired by the Brooklyn Bridge:

I think of cinemas, panoramic sleights
With multitudes bent toward some flashing scene
Never disclosed, but hastened to again,
Foretold to other eyes on the same screen;

And Thee, across the harbor, silver-paced
As though the sun took step of thee, yet left
Some motion ever unspent in thy stride,—
Implicitly thy freedom staying thee!

Crane opposes the transience of the moving picture to the permanence-in-flight of the bridge, hoping to found a new classical ethic on these modern phenomena. The ethical concern is thoroughly American, and this is where American modernism parts with its European kin. America, which was way ahead of Europe in the certainty of its allegiance to the new, was morally

conservative. The architecture of the Brooklyn Bridge, like that of New York City (or the Midwest, for that matter), put into action the principles of modern art without an attendant social or political revolution. Or, at least, not of the kind predicted by the purists. What Hart Crane wrote, despite the complexities of his philosophical qualms, was an ode to the bridge, a Whitmanesque paean to the marvelous engineering of that soaring shape. The functioning tensions were those between the relative stillness of architecture and the seeming unfolding of the moving picture. *The Bridge* was published with three photographs by Walker Evans, photographs that make unapologetic use of the many formal delights of the span in different lights. They are pictures of the bridge in motion, a moving picture of architecture. Evans's photography situated itself between architecture and the motion picture. These two poles, architecture and unfolding story, remained constant for him throughout the five decades of his career.

The twentieth century is—or maybe I should say was—the American century: demotic, technological, robust, full of bluster, simultaneously naive and cunning. The first half of it was ruled by the newspaper and the cinema.

It was also the time of popular writing, of huge advertisements, of lettering that invaded every nook and cranny and even wrote the skyline. America wrote big, with bold new alphabets, in lightbulbs, in neon, in smoke. One could follow the text of twentieth-century America from coast to coast and read it either as a single long dada phrase or as small, interlinked sections of an epic poem. Walker Evans pursued this text in all its variations, from modestly scrawled shopkeeper advertisements of the 1930s to the purely abstract graffiti of the 1970s.

In the early 1930s, Evans was fascinated by the self-referential nature of the sign, and many of his New York photographs from this period appear to be meditations on the art of photography. The striking impression of his composition, depicting the work of the General Outdoor Advertising Company in Manhattan [**p. 6**], is the photographer's delight in abstraction. The layered jumble of "Lucky Strike," the partial "Metro-Goldwyn-Mayer," the name of the billboard company, and

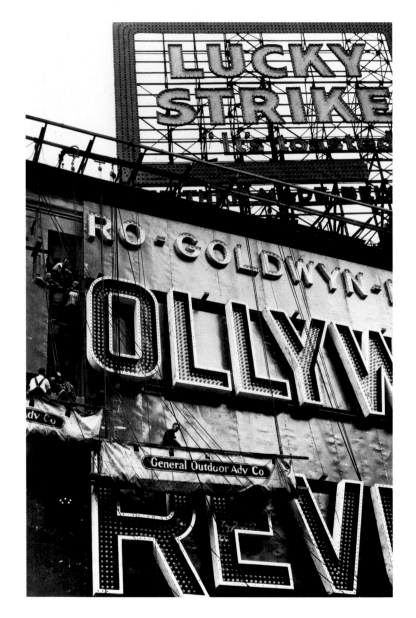

the "REV..." underneath form a concrete poem. Like Apollinaire's *Calligrammes,* or the later "concrete poetry" constructs, this image is made in conscious opposition to whatever "meaning" the signs themselves were intended to communicate. Beyond the injunction to look at these fragments of language as a picture, the only commentary involved has to do with the evident modernity of the assemblage. Here, Evans makes the same gesture the cubists, at Apollinaire's urging, made toward the Eiffel Tower: they embraced its modernity and praised its beauty at a time when the traditional art critics found it "ugly." But where,

for the cubists, embracing the Eiffel
Tower was a gesture of defiance, for Evans,
in modern America, it was merely an
acknowledgment. At the same time, to
the recently Paris-imbued traveler,
it must have been an aesthetic gesture,
as well as a homecoming.

The literary preoccupation goes in the
opposite direction as well. While language
itself is turned into an image, other pieces
of the landscape are turned into language.
The early New York pictures [**p. 9**] find
endless pleasure in uncovering shapes pro-
duced by anonymous industrial-age
artisans, as well as random instances of

city life. Letters, grids, scaffolding, fire
escapes, windows and window shutters,
chains, lunch counters with their repeated
shapes of cups, plates, and saucers, rows
of people, smokestacks, the Brooklyn
Bridge, girders, clotheslines: all become
alphabets, a writing "found" by the
camera. They are modern alphabets, but a
reader taking pleasure in "seeing pic-
tures in the clouds" might note shapes
that read as cuneiform, Babylonian,
Coptic, or Cyrillic. It is doubtful whether
any of the cabalistic preoccupations
of the Parisian surrealists had left resid-
ual concerns in the young American.
He simply uncovered a rich lode of new

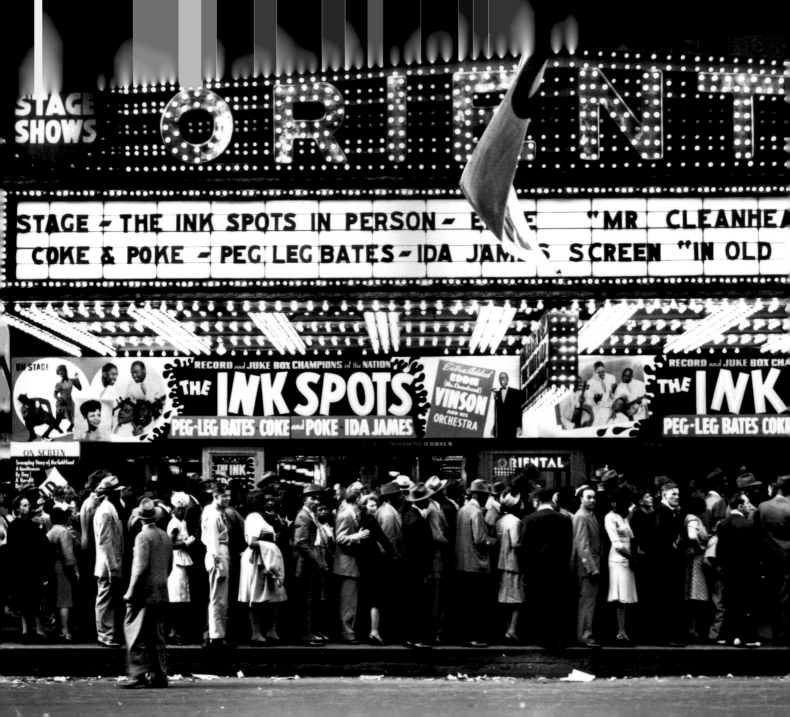

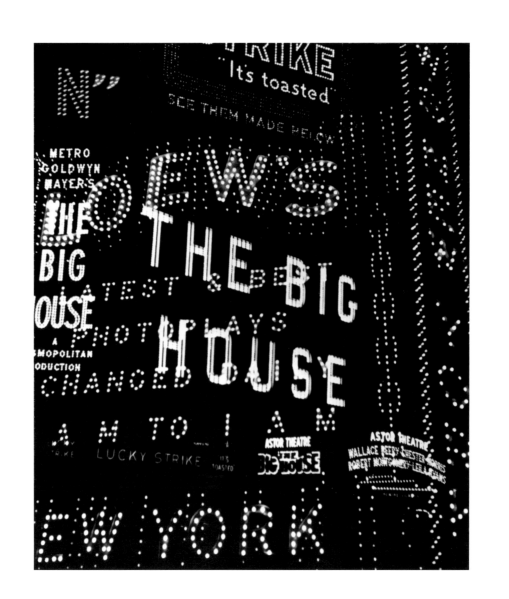

shapes and was electrified by the genius of America's anonymous workers.

The studious refusal to allow the signs "to speak" may have had something to do with the fact that Walker Evans's father worked in advertising. I might as well commit here the sin of autobiographical reference that the very soul of Evans's art would have rejected. But one can look at Walker Evans's picturing of signs as a journey along the father's body. His insistent tracking of his father's handi-work was identical to tracking America's unique role in the world: bountiful father-provider. America's signs in their sophistication or awkwardness inscribe the story of a giving, an urging to par-take in the constant overproduction of goods. This is what they urge. What they in fact do is another matter. And it may be precisely in exploring the gap between the cheerful optimism of adver-tising propaganda and the reality of Depression-stricken America that Evans found his art. In this sense, he was a midwestern son of Willy Loman, the archetypal American. There are few women in his pictures. His world is a male, industrial one, close to that of Upton Sinclair, Frank Norris, and Theodore Dreiser.

Evans would have rejected this observation for two reasons: the aesthetic purity of modernism demanded a tabula rasa from the artist, and, secondly, his social rectitude, though not strictly socialist, would have maintained that economic conditions were at the root of everyone's oppressed condition, male or female. As a modernist, he might have shrugged off the midwestern analogy because his New York sophistication was evident.

Signage combined the abstract design with the most pedestrian aims; it was both formal and representational. That alone would have been enough to make a claim to art.

As an employee of Roosevelt's great New Deal, Evans might have pointed to the leveling effect of poverty, which, even in its folkloric glory, had a flattening effect comparable to that of abstract art.

Three photographs of the early thirties stand out as exemplary of Evans's art. In one, a "sandwich man" is advertising photos at "259 Washington Street" with his back turned to the camera [p. 12]. The irony of the art photographer capturing the unaware popular photographer reappears later in his pictures of blind people. Evans was fascinated by the paradox of seeing, by capturing with his

"For Your Photos
Go To 259 Washington
St.," about 1930

PAGE 13
Royal Baking Powder
Steps, 1929

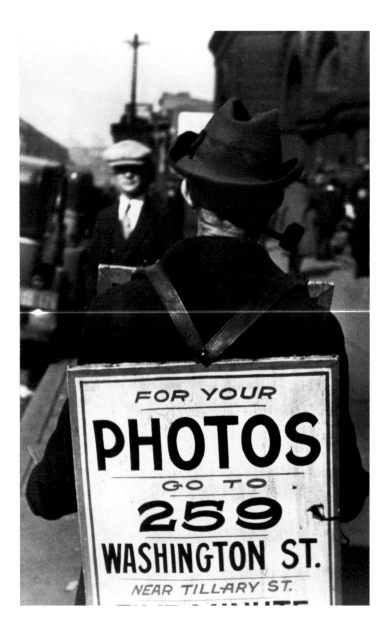

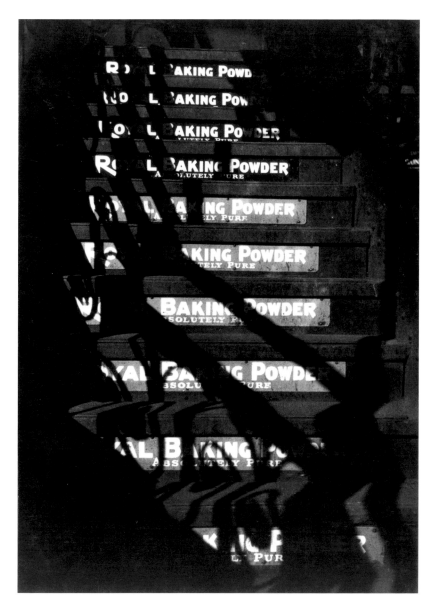

eyes for the eyes those who cannot see either their "capture" or the result of it. In this paradox, he seems to have caught the perfect combination of self-reflection and anonymity that haunts so much of his work. The subject of photography, caught in anonymous circumstances, also returns in his pictures of photography studio windows and movie posters.

In *Royal Baking Powder Steps* [**this page**], the ascending stairs carry their pathetic message into a putative heaven. I think this was, so to speak, a corner-turning picture, both personally for Evans, who composed a perfect geometric abstraction,

13

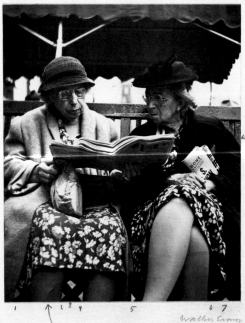

Can you
make the
words
HOME EDITION
legible without
retouching?

1 ↑ 2 3 4 5 6 7

Walker Evans

— 4" —

NOTE FOR ENGRAVER:

 Please note unsightly light triangles, seven of them, above the numbers.
Could you simply black them all out, matching the black next to them.
ALSO: Try to get clearly the veins in left leg of left woman, but without retouching.
ALSO: We want the lettering on the newspaper at right to be clear as possible, —
 again, without retouching.

 thank you, W. E.

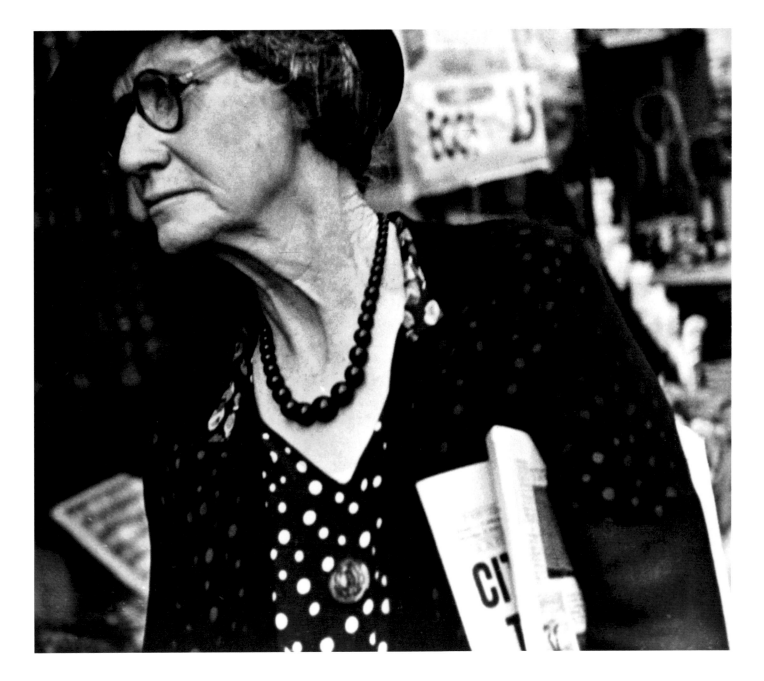

and for his successors, like Robert Frank and Andy Warhol, who absorbed it. Indeed, Warhol's Brillo boxes are an homage to it. This picture marks, if one can be neat about it, the end of the luxury of "art" for Evans, who was soon called to the front lines of photojournalism.

In *Female Pedestrian, New York* [**p.15**], an enduring textual motif makes its appearance: the newspaper. From the middle of the nineteenth century until their virtual demise in our time, newspapers were the single most important tool of working American democracy. Their importance cannot be overestimated. They were read by plebes and patricians; they were both a source of news and a prop for public life. Americans read the paper in their homes, at lunch counters, at social gatherings. The newspaper, with its assemblage of news, advertising, cartoons, and gossip, was the very picture of modernity. Powerful commentators, such as H. L. Mencken in the 1920s, could topple the high and mighty from (and with) their columns. News might spark riots or cause waves of embarrassment. In the 1930s, as the world began heading toward disaster, the newspaper became the bible of the working man. Daily, the moments of impending doom came inscribed there in bits and pieces, mixed

absurdly with cartoons and advertising. Evans's female pedestrian—an intelligent and no-nonsense woman (a teacher, perhaps)—holds under her arm a folded paper. The beginning of a headline, "CI...," is visible. The word is most likely "CITY," and the entire movement of the woman looking seriously at someone whose words she may be considering is determined by that paper and what it contains. This *is* the city, locus of conversation, center for news, place to debate the world. Behind her is the newsstand, repeating in blurred outlines the sharp text under her arm. Newspapers make numerous appearances throughout Evans's

work. In a handwritten note to the engraver on the mount of a 1941 photograph of two women sharing a newspaper in Florida [**p. 14**], Evans wrote: "Can you make the words HOME EDITION legible without retouching?" A decade earlier, legibility may not have been an issue. But consider what news that decade brought Americans: the Wall Street Crash, the Great Depression, World War II. Legibility was indeed an issue.

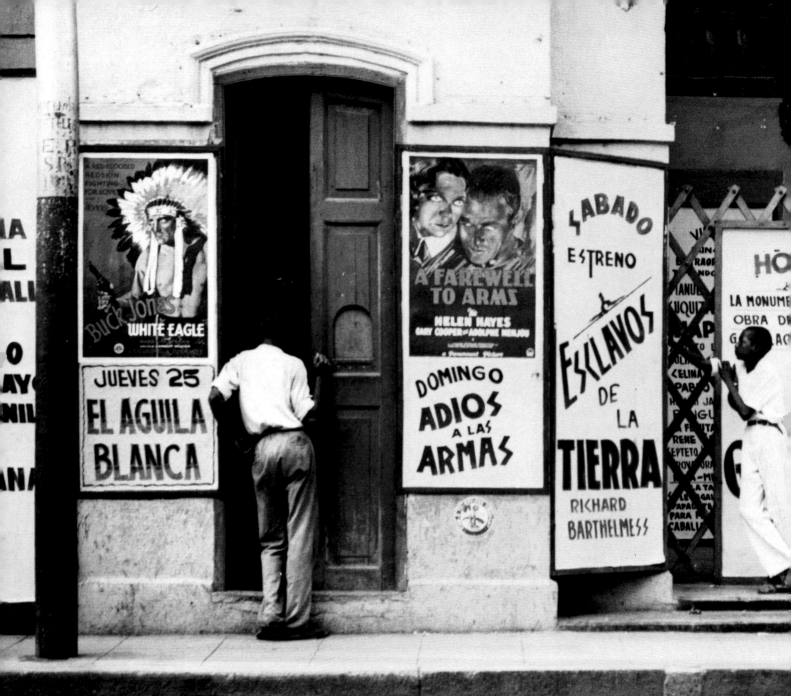

In 1933, Evans went to Cuba

to produce a series of photographs to accompany a book by Carleton Beals, a leftist journalist. This book, *The Crime of Cuba*, was published in 1933 with thirty-one photographs by Walker Evans. The Beals book was grounded in the leftist ideology that captured nearly all notable American writers and artists of the time. Particularly important to Evans was the scandal accompanying Diego Rivera's mural for Rockefeller Center in New York City. The Mexican muralist had included a portrait of Lenin and an idealized Soviet-type worker in his fresco. Rockefeller ordered the mural boarded up and then destroyed. Evans had watched the work in progress and was outraged,

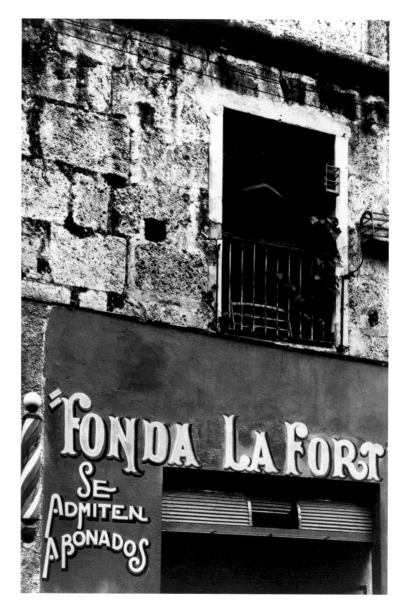

along with most New York intellectuals at
the time. Rivera's work was in fact a kind
of sloganeering: his figures could just
as well have been ten-foot red letters on a
black background. The bold calligraphy
of most social-realist art was a feature of
the times. Evans's attraction to the ide-
ology may have been lukewarm (after all,
he had worked on Wall Street and later
had a permanent job at *Fortune*, America's
premier capitalist publication); even
so, he doubtlessly admired the *writing*
of the Revolution. This writing, on a
huge scale, had evolved directly, via the
poet Mayakovsky and others, from Russian
constructivism.

PAGE 22
Havana Shopfronts,
1933

PAGE 23
Colonnade Shop,
Havana, 1933

In Cuba, fired up by socialism, Evans set out to photograph the misery inflicted on Cubans by American imperialism. But his camera had a mind of its own. It was drawn, first of all, to the extraordinary faces on Havana streets, to the large crowds, to pushcarts, and then to the posters for American movies. He also photographed facades of Havana buildings that spoke to his ongoing textual investigation. These were rich in signification and a lot more human-scaled than the mega-signs of New York.

In *Havana Cinema* [**p.18**], a white-shirted black man is looking into the dark door-way of a movie house. On either side of him are movie posters, including *Adios a las Armas* (A Farewell to Arms). In Cuba, Evans met Hemingway, and the two men became friends. This photograph may well be an homage to Hemingway, but it is also a picture that insists on the literal message being expressed in words. The other movies being shown are *El Aguila Blanca* (The White Eagle) and *Esclavos de la Tierra* (Slaves of the Earth). It is impossible not to read these titles as a haiku history of Cuba. Nor is this the only Cuban picture where the message of the text is not actively suppressed. In *Small Restaurant, Havana* [**opposite page**], the name of the establishment, "Fonda la Fortuna" (cropped in the middle of the word "Fortuna" in the print reproduced here) stands above "Se Admitten Abonados" (Members Only), which is a kind of guarantee of

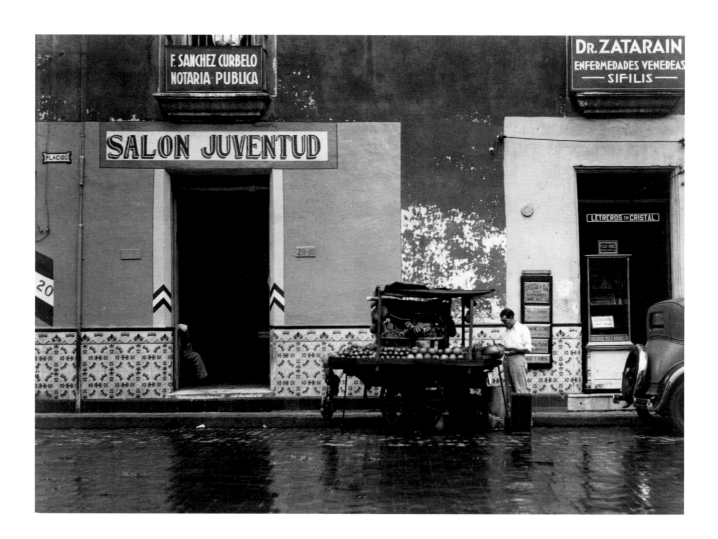

22

"How could there be a depression in America when there are so many cars?"

respectability. This may have been a particularly important message to wealthy Americans who thought of Cuba as their private whorehouse. (The old-fashioned, neocolonial writing of this fonda's name, set off by quotation marks, reinforces the message.) In *Havana Shopfronts* [**p.22**], three businesses share the space: a beauty salon, a notary public, and Dr. Zatarain, who specializes in "Enfermedades Venereas—Sifilis—." The messages do not shy away from us. They are meant to be read.

This was the question my uncle, who was a photographer in Transylvania, Romania, once asked my father. Well, compared to Romania, there may have been a lot of cars in America during the depression, but then, without cars, one could hardly conceive of America. Henry Ford (whose son, Edsel, *did* allow Diego Rivera to depict his assembly line in murals at the Detroit Institute of Art) had made America dependent on the automobile: without the car, Americans could not exist. An

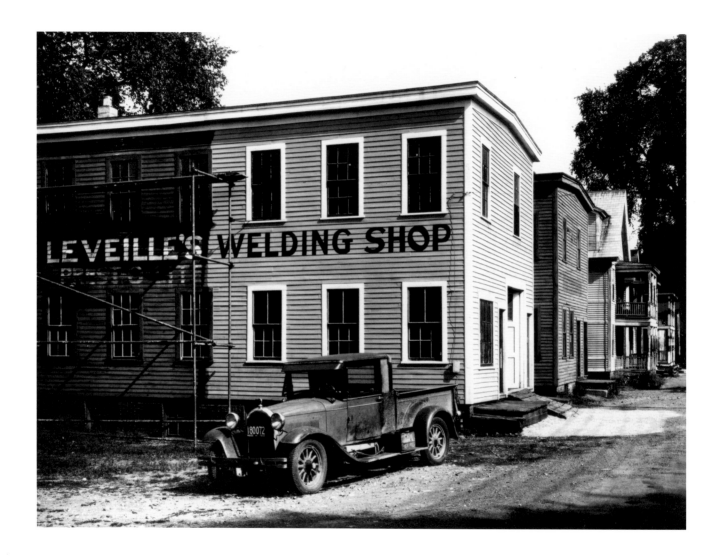

PAGE 28
White House Garage,
New York, about 1934

PAGE 29
Garage in Southern
City Outskirts (detail),
1936

amount of time equally great to that given over to the care of their souls by innumerable churches was given over by Americans to the care of their cars.

Leveille's Welding Shop [opposite page] in a Massachusetts town gives us a glamour shot of an automobile. The bare New England street stretches from a tree in the distance to the license plate of the car. Evans photographed many cars, possibly as part of a project echoing Atget's pictures of horse-drawn carriages in Paris. In *White House Garage, New York* [p.28], a truck inside the open door of a garage is framed by all the reverence due a church saint, perhaps Jesus himself. Three men are posing in front of it. The signs read "White House Garage," "Day and Night Parking," "Plymouth-Service-Dodge." To the side is another truck, parked deferentially as if awaiting its turn to worship. Above it are other signs for car care, crowded in the building like icons. This mystical truck reappears in different incarnations throughout Evans's America. At a garage in Atlanta, Georgia [p.29], the car parked beneath the "Cherokee Parts" sign is surrounded by the O's of hanging tires. The tires look as if they would like to form a word, but they can only say O O O O, like someone struck by awe.

OFFICIAL FRONT WHEEL & AXLE ALIGNMENT SERVICE
[29] PREVENT SHIMMY, HARD STEERING & TIRE WEAR **[29]**
Blue Ribbon Service Station, INC.

WHITE HOUSE GARAGE.

MAJOR
&
MINOR
REPAIRS

TEXACO
XTER
GHT
SYSTEM

[29]
AUTO
RADIO
CO.
SALES
SERVICE
EXPERT
INSTALLATION

DAY and NIGHT
PARKING.

BRAKES

RELINING-ADJUSTING
Raybestos
WOVEN MOLDED
BRAKE LINING

BROWNIES

B ROW

FEDERAL

ROCITTO
E SERVICE

WELDING

PLYMOUTH- **SERVICE** - DODGE

PALUMBO

The 100%
ANTI-KNOCK
regular

DANGER

SHELL
MOTOR
OILS

GLASGOW IRON WORKS
28
AND SUPPLY CO.

EXPERT
AUTO
REPAIRS

SHELL
MOTOR OIL

WASHING

SIMONIZING

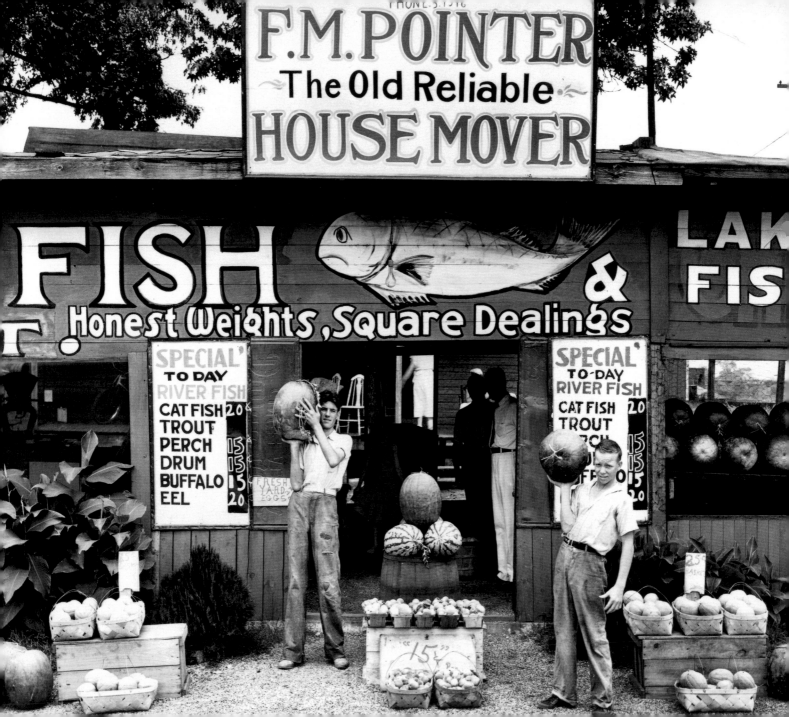

PAGE 32
Sidewalk and Shopfront,
New Orleans, 1935

PAGE 33
Star Pressing Club,
Vicksburg, Mississippi,
1936

Depression-age America often speaks through prices. The prices of food and entertainment are boldly advertised. Cheap movies and dances exert a hypnotic draw.

The *Roadside Stand Near Birmingham* [**opposite page**] boasts of "Honest Weights, Square Dealings." It is a fish store, and it appears to burst with bounty. The hand-lettered sign "TO DAY RIVER FISH" boasts of "CATFISH 20, TROUT, PERCH 15, DRUM 15, BUFFALO 15, EEL 20." A boy and a young man stand in front of the store hefting watermelons. This might look like paradise to a starving Transylvanian of that era, but this is subsistence living: all the fish come from the river, and they are cheap, it is true, but fifteen cents may have been a big deal. This particular photograph had a curious echo for me. When I first moved to Louisiana, I drove past a little store in Baton Rouge that bore a sign nearly identical to the one in the Evans photograph. I turned to my companion and said: "Looks just like a Walker Evans."

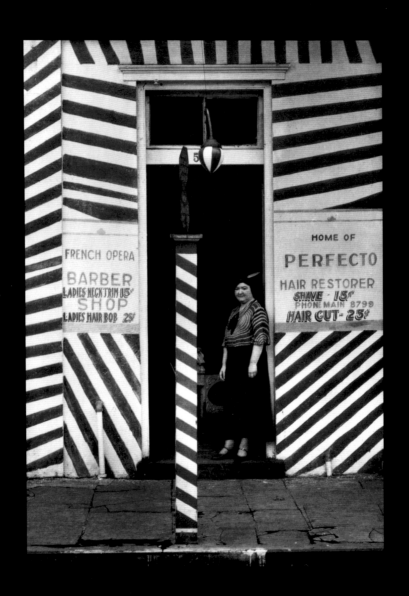

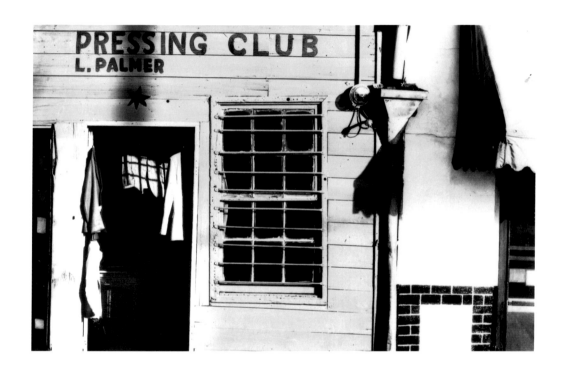

Two Elderly Men
Conversing, 1936

PAGE 36
Stable, Natchez,
Mississippi, 1935

PAGE 37
Church of the Nazarene,
Tennessee, 1936

There is still plenty of America that looks just like a Walker Evans. In the mid-1930s he photographed the rural South on several occasions for the New Deal's Resettlement Administration, documenting American small-town life. This work took him to Kentucky, Tennessee, Alabama, Mississippi, and Louisiana. In the summer of 1936 he returned with his friend James Agee to work on a piece on "cotton tenantry in the United States." The book that resulted, *Let Us Now Praise Famous Men,* with thirty-one photographs by Walker Evans, would be published in 1941. In 1937 he photographed flood refugees in Arkansas and Tennessee.

The Americans of those days were tired people. But even in their exhaustion, as they stand in front of their stores or pass time on a wooden bench in front of the barbershop, there is a determined ease in their stance.

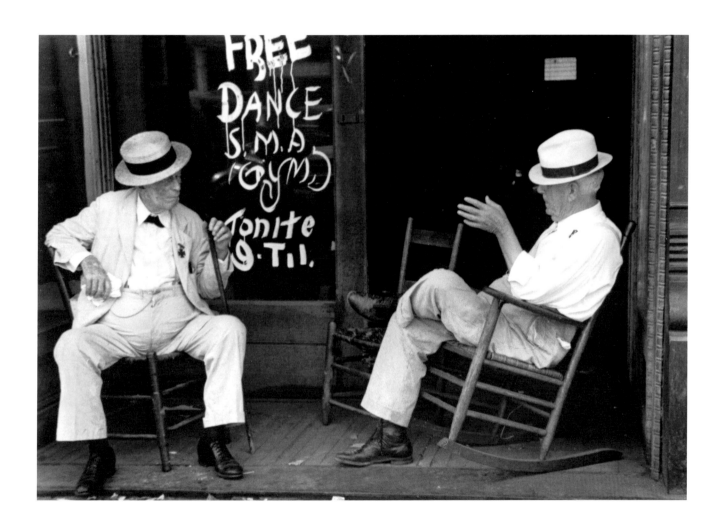

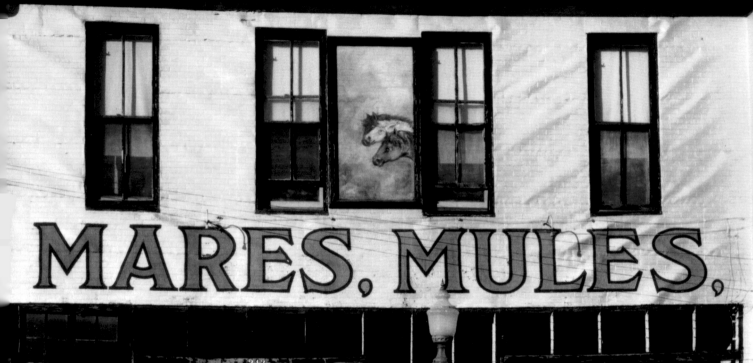
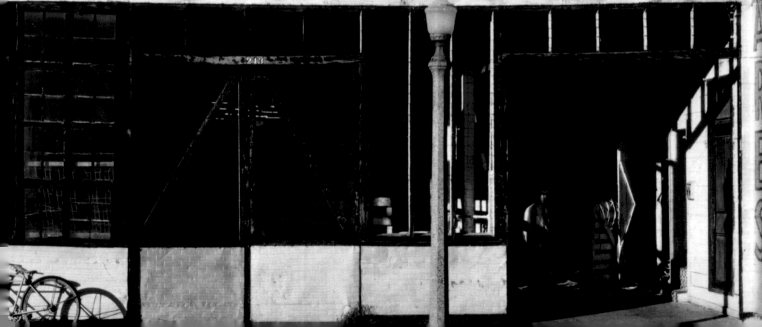

MARES, MULES,

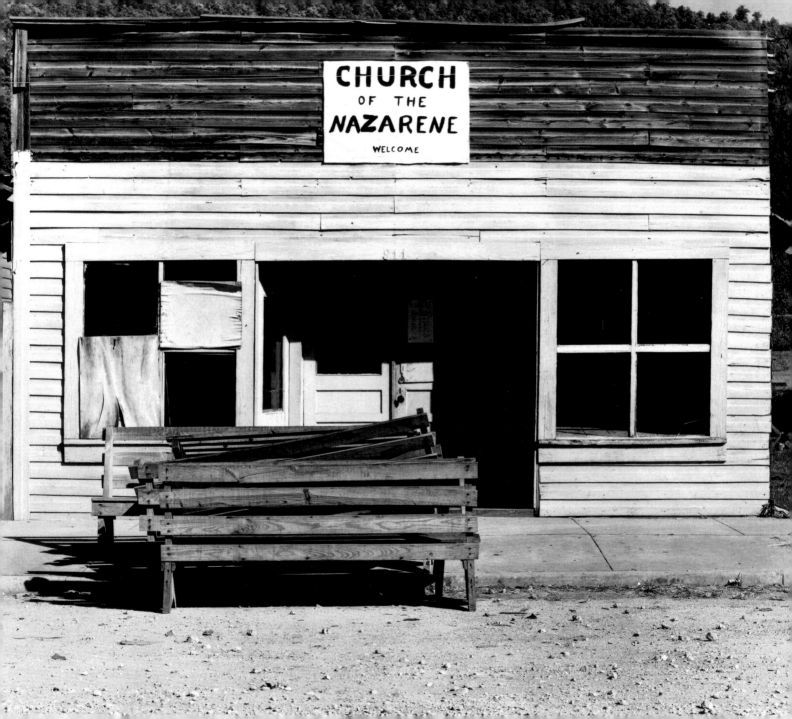

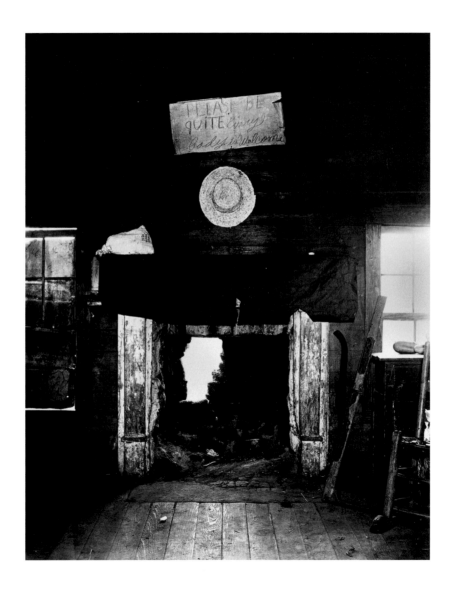

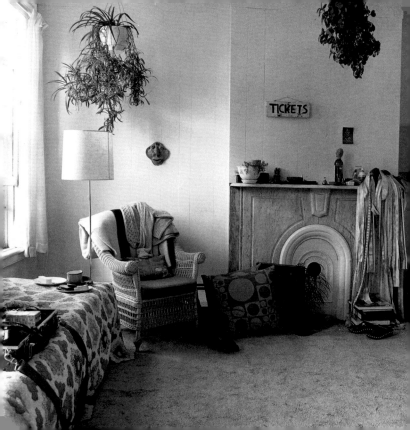

They are barefoot, their children are ragged, but they are at home. Evans did not document the great westward migration of the Dust Bowl, but some of his subjects may have been on the verge of leaving. Their clapboard shacks are bare. The writing that occasionally frames their world is the hand-lettered sign. "PLEASE BE QUITE every body is Welcome": each word is scripted differently above the fireplace in the "cotton room" of a tenant farmer in Hale County, Alabama [**p.38**]. A somber man sits in Vicksburg, Mississippi, beneath a barbershop sign:

"Hair Cut 25¢. E. C. Clay Barber Shop" [**opposite page**]. These are, recognizably (and classically), Walker Evans photographs, but we are no longer in the strict formal universe of the New York signage of 1930.

Walker Evans's fascination with writing had a life of its own. He never stopped producing pictures that turned their subjects into script and thus, implicitly, into reflections on art.

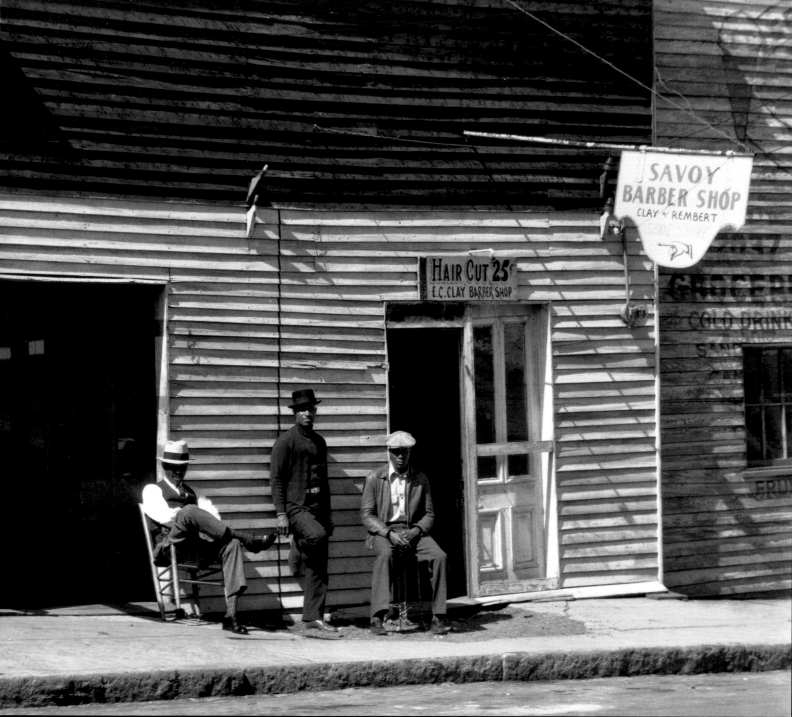

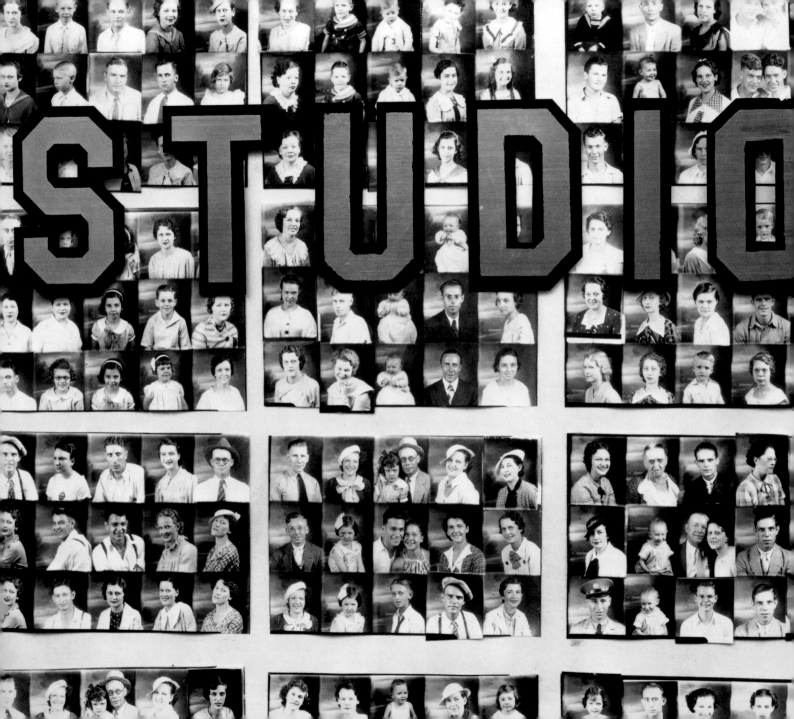

The *Photographer's Window Display, Birmingham, Alabama* [**opposite page**] features the gallery of a studio photographer's portraits under the window sign "STUDIO." What was his interest in these formally posed portraits, in all respects the opposite of his own approach to portraiture? Was he contrasting his craft with that of the hackwork of the studio photographer? Or was he expressing a wariness, an exhaustion, much like that of the tired people he saw through his viewer? Clearly, Evans hated to bother people and preferred to shoot them from the back or from above. Perhaps this too is why he liked to photograph the blind. But the shy impulse that made him want to disappear behind the camera is a writerly impulse. Evans used his camera like a typewriter and would have preferred to be alone like a writer.

This apparent paradox is partially explained by the New York subway series, eighty-nine of which were eventually collected in the book *Many Are Called*. Evans took pictures of New York subway riders secretly, using a hidden camera [**pp. 44, 45**]. The faces of these New Yorkers of the 1940s reveal a weariness that is no less tragic than that of the cotton farmers of the 1930s. Although these are city people in a public setting, they

43

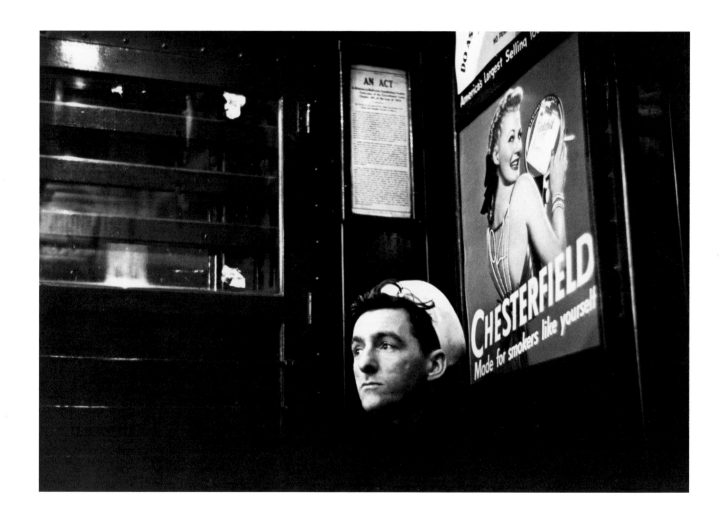

Subway Portrait,
1938–41;
printed about 1965

Subway Portrait,
1938–41;
printed about 1965

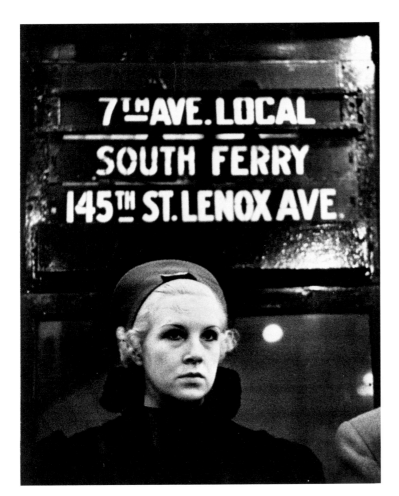

exist in a near-absolute loneliness. The world, as reflected in the myriad tensions in their eyes and face muscles, is heavily with them. They are better dressed than the country people, some of the women are even pretty, but there is no genuine happiness in any of them. Subway riders do not, even now, reveal much tenderness, but looking back on these people one can certainly feel the burden of the times. Black-and-white seems their only possible medium.

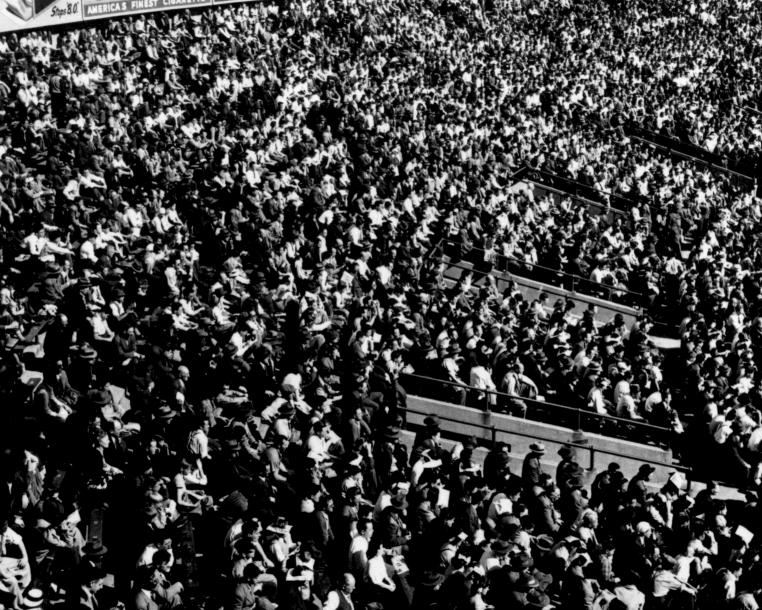

Yankee Stadium
with Capacity Crowd
and Billboards (detail),
1946

P A G E 4 8
Bridgeport's Italian
Women Insist Upon
Their Patriotism, 1941

P A G E 4 9
Parade Watchers
in Bridgeport
(detail), July 6, 1941

The writing that accompanies Evans's subway riders is mostly the names of stations, impersonal places of egress that will suck them back into the anonymity Evans has briefly pulled them from.

The "masses," that ideology-laden, bottom-heavy notion of the socialist thirties, underwent a thorough examination by Evans's camera.

He photographed the "many," both in their public-private spheres and in anonymous quantity. A very clear "Marxist" picture is the 1946 *Yankee Stadium with Capacity Crowd and Billboards* [**opposite page**], in which thousands of fans swarm unconsciously under advertising for Philip Morris, Burma-Shave, and others. The capitalism that rules these people's lives is no longer hidden, as in the "capitalist conspiracy" of earlier times: it's up there for all to see, in the sky, like God. Patriotism and its crowds come in for a share of critical observation by Evans's camera in the forties.

The (uncharacteristically) ironically captioned *Bridgeport's Italian Women Insist Upon Their Patriotism* [**p.48**] looks straight at grimly cherubic believers passing by in a flag-adorned car with the sign "Love or Leave America."

47

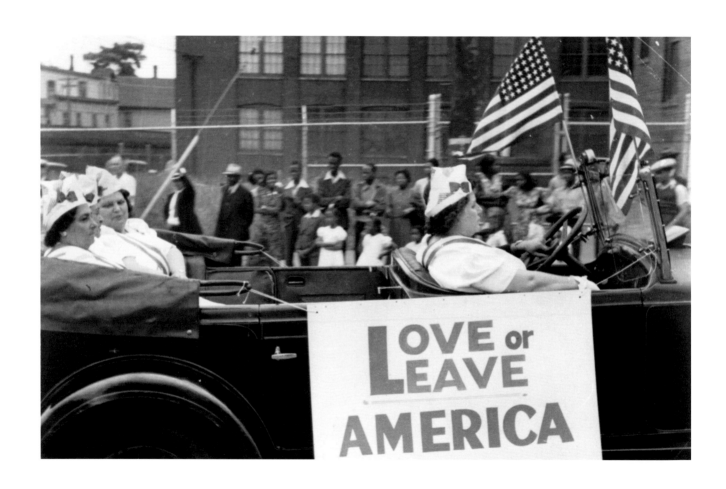

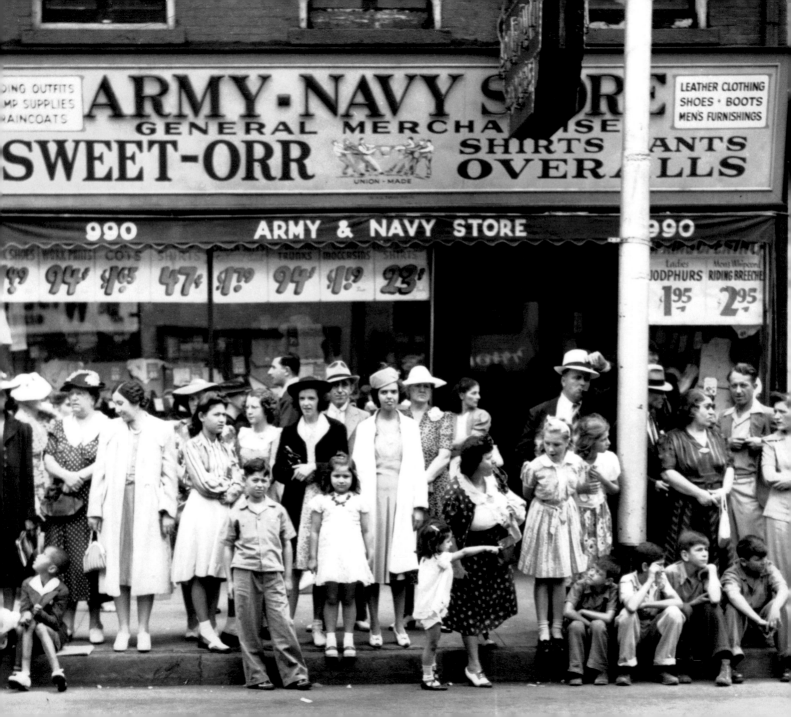

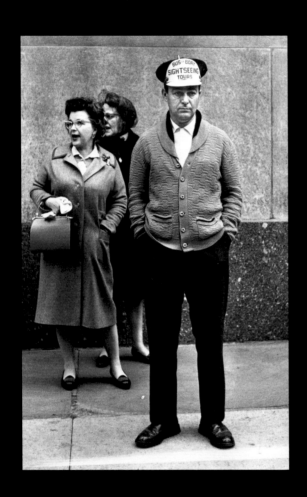

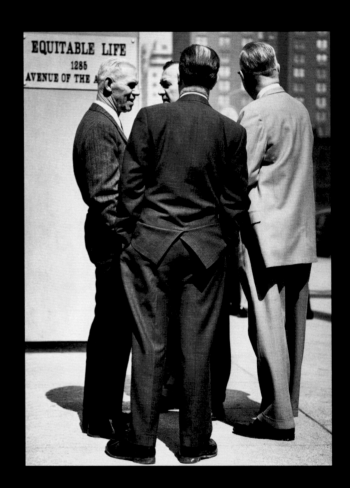

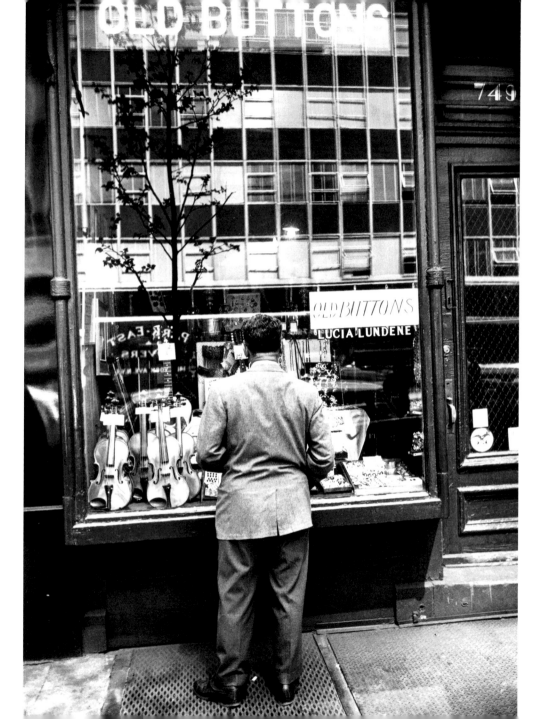

Beneath the obvious flummery, there is pathos: Italians were the enemy, so Italian-Americans had to overdo their patriotism.

For the more private relationship between advertising and the human soul, there is the 1941 *Subway Portrait* [**p.44**] of a pensive sailor beneath a Chesterfield ad. This man, whatever his thoughts, is part of a triply-anonymous mass: that of soldiers, of subway riders, and of advertising consumers. Evans's intuitive grasp of loneliness foreshadowed the "alienation" central to post-war existentialism.

In the 1935 *Interior Detail, West Virginia Coal Miner's House* [**opposite page**], a Coca-Cola ad featuring a Santa and a graduation poster stand filled with cheer over an ornate empty rocker. The owner has gone, maybe to look for work: the ads themselves, not what they promise, are all that's left. The picture vibrates with absence.

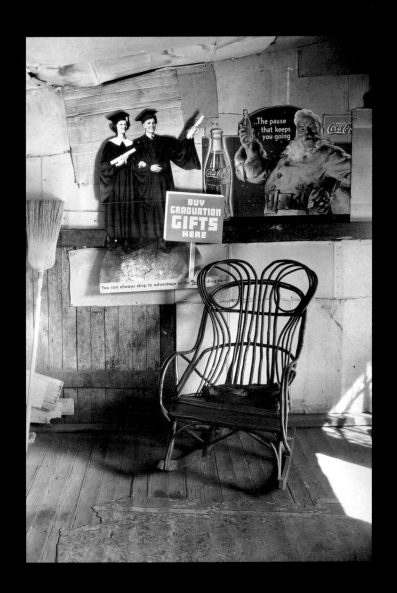

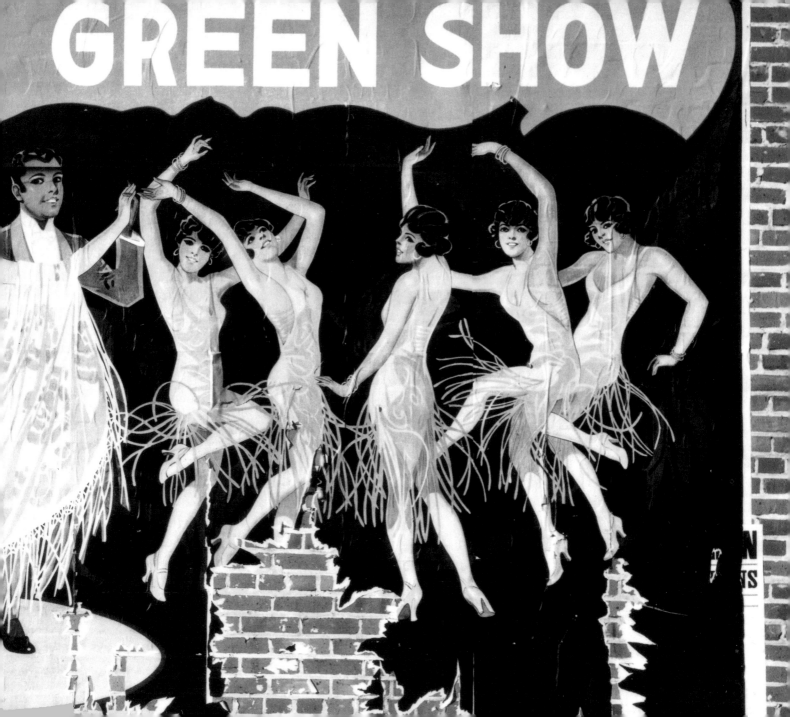

Advertisements themselves, without any humans,

often came within the purview of Evans's lens. *Show Bill, Demopolis, Alabama* [**pp. 54, 55**] displays a racy poster for the "Silas Green Show" on a brick wall. The poster shows a (possibly) black man dancing with a frilly flapper. Evans was keenly aware of the temporality of advertising and thus of a fundamental feature of American life: the relentless constancy of change. The ads he photographs already look nostalgic. The movie posters hawking *The Man from Guntown* and *I Hate Women* [**opposite page**] are eternally lurid though clearly destined for the trash heap. This is perhaps one of the unintended ironies of photography: the ephemeral and the enduring are indiscriminately preserved on film.

Not all of Walker Evans's pictures of advertising have the same quality of critique, however. The sign for "French Cleaners" in *New York City* [**p. 58**] is simply a delightful image, and Evans photographed it with the care he had taken in photographing African art in 1935. It is a typically Evans letter-poem framing an aesthetic discovery.

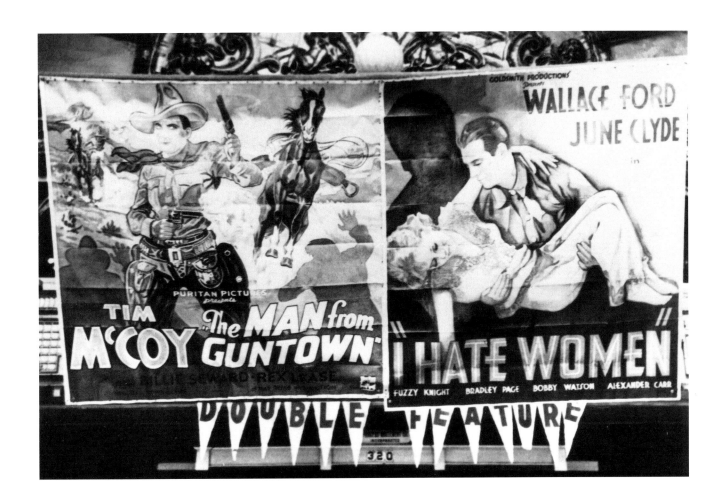

New York City, 1937

Lunch Wagon Detail,
New York, 1931

Movie Poster,
Louisiana, about 1935

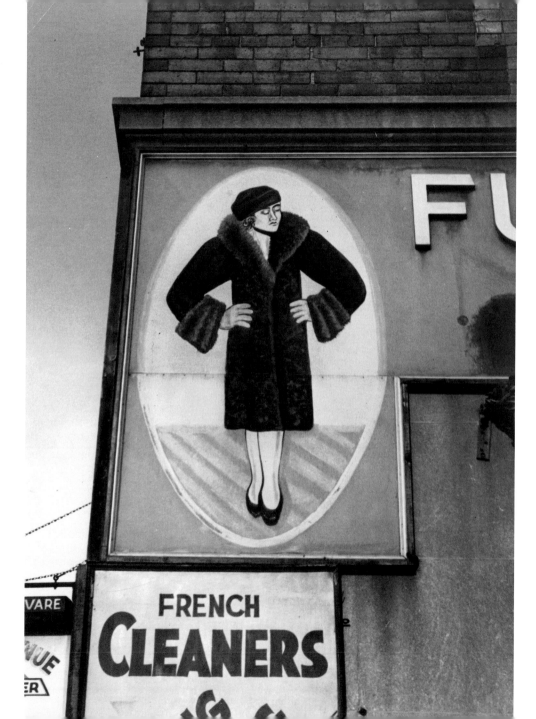

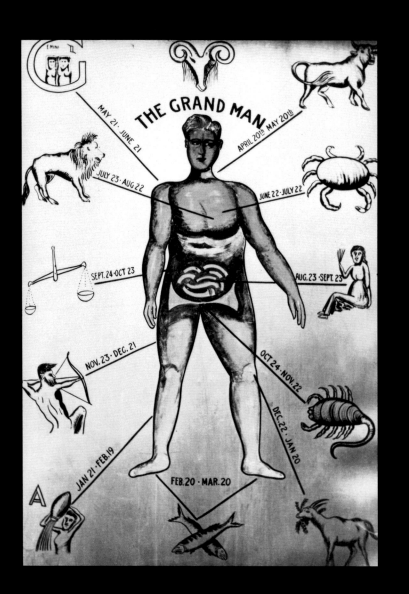

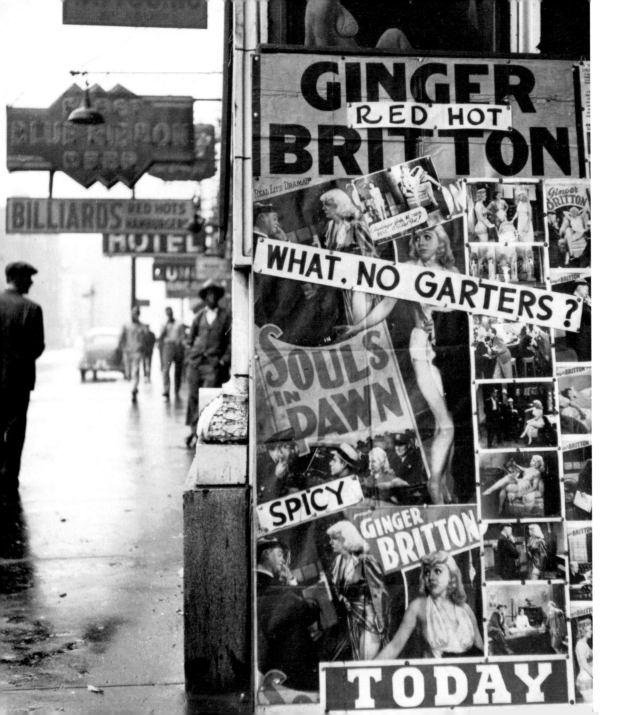

Cleaners, clotheslines, and uninhabited dresses make frequent appearances, a whimsy that Evans may have caught from the surrealists and which he certainly passed on to his pop successors, like Jim Dine.

Walker Evans's discovery of color came before he actually began using it. His Gulf Coast series, though still black and white, has hints of color in it; the place and its denizens tint these pictures from within. The *Municipal Trailer Camp* [p.64] with its flower boxes is a har-binger of fifties American kitsch in full gaudy bloom. Evans photographed the

winter home of the Ringling Brothers circus in Florida, with its carved wagons, elephant "kraal" [p.65], and lion cage. The atmosphere of wartime Florida is far removed from the Depression. The place is animated by a future of roadside attrac-tions, mass-produced trivia, rivers of baubles, cheap plastic, portable housing, and lawn furniture. Once more, Evans's eye discerned within the present the genetic makeup of something yet unborn.

All writing is abstraction that points, paradoxically, toward representation. Evans's early sign photographs point, inversely, toward abstraction.

PAGE 64
Municipal Trailer
Camp, 1941

PAGE 65
Elephant Building,
Winter Quarters,
Sarasota, 1941

Later, the composition appears to share room with the message. One can look at these photographs as concrete poems or as documents; they work both ways. Walker Evans portrayed America, but he also created a Walker Evans America and, by extension, a Walker Evans text. This poem can be read in any number of ways: chronologically or randomly. Surprisingly, it is a more coherent poem than *The Bridge*, Hart Crane's anguished lyric, because the tensions of the creator are dissolved in the seeming objectivity of the camera. I say "seeming," because the effort to create just the right distance is written in every picture. Whatever that distance was, it became just the right distance for the following generation of photographers. Evans showed us how to see America, and we continue, for the most part, to see it his way.

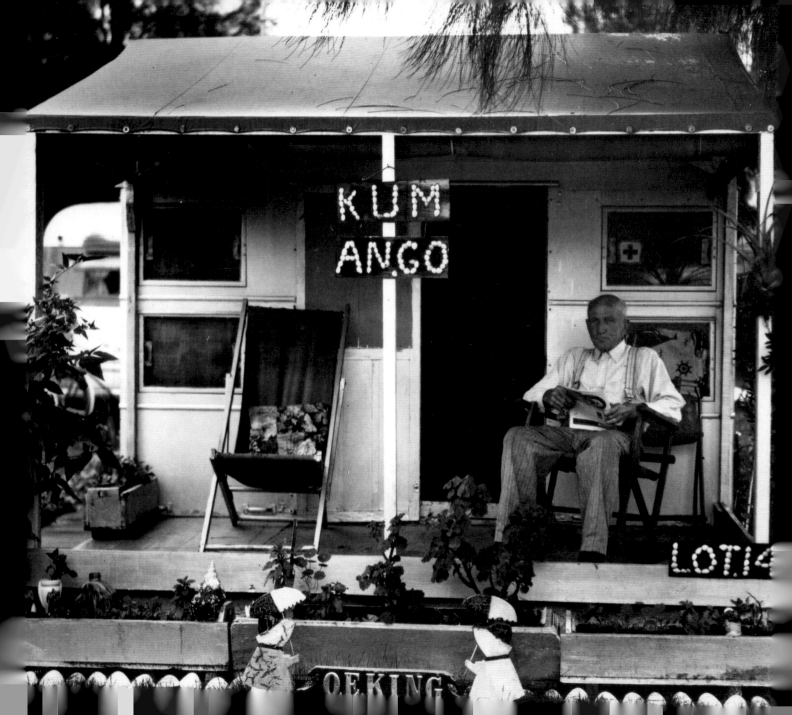

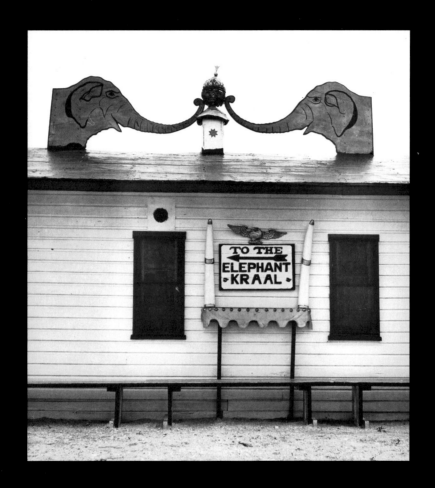

The Photographs

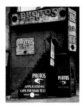

East Entrance

about 1947; printed 1949
12 13/16 × 15 1/16 in.
84.XM.129.17

PAGE i

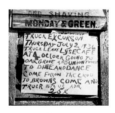

License Photo Studio,
New York

1934
7 3/16 × 5 11/16 in.
84.XM.956.456

PAGE ii

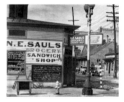

Street Scene,
New Orleans, Louisiana

1935; printed later
8 3/16 × 10 in.
84.XM.129.8

PAGE iii

Highway Sign,
Outside Chicago

1947
6 29/32 × 6 7/8 in.
95.XM.45.45

PAGE iv

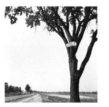

Excursion Sign

1936
4 15/32 × 4 25/32 in.
84.XM.956.373

PAGE v

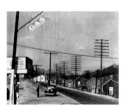

Roadside View, Alabama
Coal Area Company Town

1935
7 3/16 × 8 13/16 in.
84.XM.956.498

PAGE xi

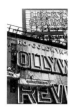
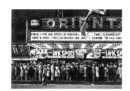

Outdoor Advertisements

about 1929
8 5/8 × 5 11/16 in.
84.XM.956.137

PAGE 6

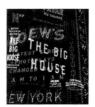

"Evening in the Loop"

1946
6 3/16 × 8 3/4 in.
84.XM.956.968

PAGE 8

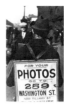

Times Square

1930
10 5/8 × 9 1/4 in.
84.XM.956.46

PAGE 9

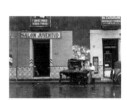

**"For Your Photos
Go To 259 Washington St."**

about 1930
7 3/4 × 4 13/16 in.
84.XM.956.66

PAGE 12

Royal Baking Powder Steps

1929
7 3/4 × 5 9/16 in.
84.XM.956.64

PAGE 13

**Winter Resorters,
Florida**

1941
5 5/8 × 4 21/32 in.
84.XM.956.947

PAGE 14

**Female Pedestrian,
New York**

about 1929–31
5 11/16 × 6 9/16 in.
84.XM.956.88

PAGE 15

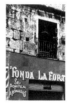

Havana Cinema

1933
5 13/16 × 9 1/4 in.
84.XM.956.142

PAGE 18

**Small Restaurant,
Havana**

1933
7 1/4 × 4 25/32 in.
84.XM.956.209

PAGE 20

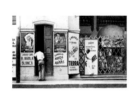

Havana Shopfronts

1933
6 3/4 × 9 15/32 in.
84.XM.956.259

PAGE 22

**Colonnade Shop,
Havana**

1933
6 11/16 × 9 5/16 in.
84.XM.956.266

PAGE 23

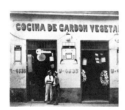

Havana

1933
6 1/16 × 7 1/16 in.
84.XM.956.146

PAGE 24

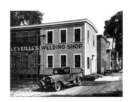

Leveille's Welding Shop

1934
5 5/8 × 7 21/32 in.
84.XM.956.133

PAGE 26

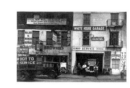

**White House Garage,
New York**

about 1934
5 11/16 × 9 1/32 in.
84.XM.956.67

PAGE 28

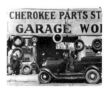

**Garage in
Southern City Outskirts**

1936
6 27/32 × 6 15/16 in.
84.XM.956.447

PAGE 29

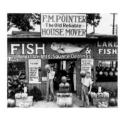

Roadside Stand
Near Birmingham

1936
7 1/4 × 8 13/16 in.
84.XM.956.519

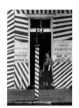

Sidewalk and Shopfront,
New Orleans

1935
6 1/16 × 4 9/32 in.
84.XM.956.476

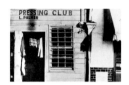

Star Pressing Club,
Vicksburg, Mississippi

1936
3 13/32 × 5 3/8 in.
95.XM.45.17

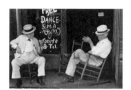

Two Elderly Men
Conversing

1936
5 31/32 × 8 19/32 in.
84.XM.956.293

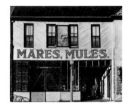

Stable, Natchez,
Mississippi

1935
6 7/8 × 8 1/4 in.
84.XM.956.332

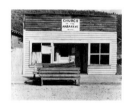

Church of the Nazarene,
Tennessee

1936
7 3/16 × 9 1/8 in.
84.XM.956.510

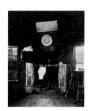

The Cotton Room at Frank
Tengle's Farm, Hale County,
Alabama

1936
9 15/16 × 7 31/32 in.
84.XM.956.353

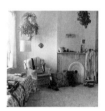

Melinda Blauvelt's
Room

about 1971
9 29/32 × 9 11/16 in.
95.XM.45.105

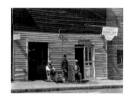

Sidewalk Portrait of Three
Men, Vicksburg, Mississippi

1936
7 5/32 × 9 15/16 in.
84.XM.956.303

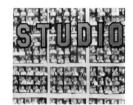

Photographer's Window
Display, Birmingham, Alabama

1936
7 1/16 × 8 7/16 in.
84.XM.956.463

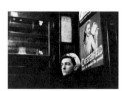

Subway Portrait

1938–41;
printed about 1965
6 15/16 × 10 1/16 in.
84.XM.956.644

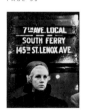

Subway Portrait

1938–41;
printed about 1965
14 × 11 1/16 in.
84.XM.956.562

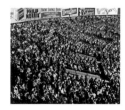

Yankee Stadium with Capacity
Crowd and Billboards

1946
6 17/32 × 7 11/16 in.
84.XM.956.1081

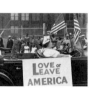

Bridgeport's Italian Women
Insist Upon Their Patriotism

1941
5 3/16 × 8 1/4 in.
84.XM.956.123

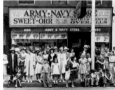

Parade Watchers in
Bridgeport

July 6, 1941
6 29/32 × 8 25/32 in.
95.XM.45.28

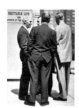

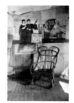

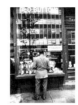

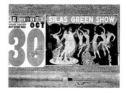

Tour Guide, New York,
for the series "Dress"

1963
13 3/32 × 8 15/32 in.
95.XM.45.71

PAGE 50

Four Businessmen, New York,
for the series "Dress"

1963
9 3/4 × 7 3/32 in.
95.XM.45.60

PAGE 50

"Old Buttons,"
Third Avenue, New York

1962
13 9/16 × 9 17/32 in.
95.XM.45.50

PAGE 51

Interior Detail, West Virginia
Coal Miner's House

1935
9 5/16 × 6 9/32 in.
84.XM.956.518

PAGE 53

Show Bill,
Demopolis, Alabama

1936
6 1/8 × 8 9/16 in.
84.XM.956.294

PAGE 54–55

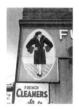

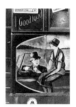

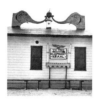

Movie Poster,
Louisville, Kentucky

1935
4 25/32 × 7 3/16 in.
95.XM.45.12

PAGE 57

New York City

1937
8 3/4 × 6 1/16 in.
84.XM.956.1078

PAGE 58

Lunch Wagon Detail,
New York

1931
7 3/4 × 5 3/8 in.
84.XM.956.516

PAGE 59

Movie Poster,
Louisiana

about 1935
10 × 8 in.
94.XM.64

PAGE 59

"The Grand Man"

about 1935
6 7/16 × 4 7/16 in.
84.XM.956.1074

PAGE 60

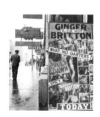

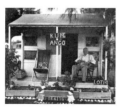

Chicago
("What, No Garters?")

1946
7 × 6 5/16 in.
84.XM.956.954

PAGE 61

Municipal Trailer Camp

1941
6 1/32 × 7 3/32 in.
84.XM.956.798

PAGE 64

Elephant Building,
Winter Quarters, Sarasota

1941
6 25/32 × 6 5/32 in.
84.XM.956.883

PAGE 65

Library of Congress
Cataloging-in-Publication Data

Evans, Walker, 1903–1975.
 Walker Evans : Signs /
 with an essay by Andrei
 Codrescu.
 p. cm.
 ISBN 0-89236-376-2
 1. Photography, Artistic.
2. Signs and signboards—
Pictorial works. 3. Evans,
Walker, 1903–1975.
I. Codrescu, Andrei,
 1946– . II. J. Paul Getty
Museum. III. Title.
TR654.E918 1998
779'.092—dc21 98-4270
 CIP

The J. Paul Getty Museum
1200 Getty Center Drive
Suite 1000
Los Angeles, California
90049-1687

Second printing

Publisher
Christopher Hudson
Managing Editor
Mark Greenberg

PROJECT STAFF

Editor
John Harris
Designer
Jeffrey Cohen
Production Coordinator
Suzanne Petralli Meilleur
Photographers
Charles Passela
Ellen Rosenberg
*Cataloging Assistant,
Department of Photographs*
Michael Hargraves

Judith Keller and John
Harris would like to thank
Ken Breisch for his help.

Printed by The Stinehour Press
Lunenburg, Vermont

Bound by
Acme Bookbinding
Charlestown, Massachusetts

The J. Paul Getty Museum
acknowledges the coopera-
tion of The Walker Evans
Archive at The Metropolitan
Museum of Art.

Front cover and frontispiece:
*Chicago ("What? No
Garters?")* (details), 1946;
see p. 61.

Back cover: *Subway
Portrait*, 1938–41, printed
about 1965; see p. 45.